The Hawaiian Tattoo

by P.F. Kwiatkowski
with illustrations by
Tom O'o Mehau

Halona, Inc.
Kohala, Hawaii
1996

PUBLISHED BY Halona, Inc.
Copyright 1996 Halona, Inc.
All Rights Reserved Printed in
Honolulu, Hawaii, USA
ISBN 0-9655756-0-8

TABLE OF CONTENTS

ACKNOWLEDGMENTS .. v

FORWARD ... vii

CHAPTER 1 ... 1
 A BRIEF HISTORY OF TATTOOING
 Hawai'i and Polynesia

CHAPTER 2 ... 9
 TECHNIQUES AND TERMINOLOGY

CHAPTER 3 ... 19
 TATTOO DESIGNS AND THEIR RELATIVES

CHAPTER 4 ... 27
 BASIC GEOMETRIC DESIGNS

CHAPTER 5 ... 35
 THE 'AUMAKUA

CHAPTER 6 ... 43
 FLIGHTS OF FANCY
 PROOF OF GRIEF
 MARKS OF SHAME

CHAPTER 7 ... 49
 EVOLUTION

BIBLIOGRAPHY ... 57

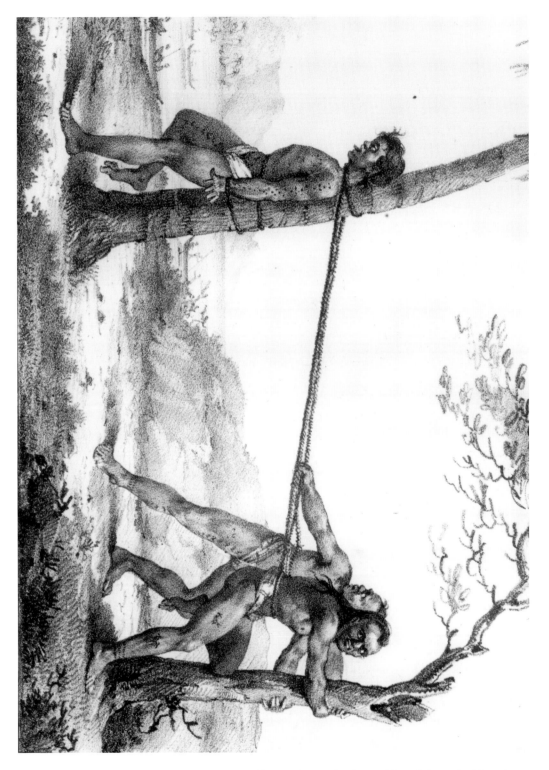

"Strangulation" by Arago. Hawaii State Archive photo.

▲▲▲

ACKNOWLEDGMENTS

Any book, much like a house being built, is done so with the input and help of many friends, acquaintances, helpers and facilitators, all of whom make some contribution to the finished product. This book is a product of all of the above and also includes the understanding and patience of those closest to the writer and artist. Both the artist, Tom Mehau, and I have "other things" to do and we are indeed fortunate to have families that understand the time and effort involved in putting together a work such as this. My wife Darlene has been my biggest supporter, helper and associate researcher. Mahalo Hunny. Mahalo to our families, Michi and Derrick Hanano, Larry and Beverly Mehau, and Irene and Lacy Mehau. To our "models," George Mehau, Jr., Augie Alameda, William Kalaniopio and Kimo Lim, aloha pumehana.

To the staff of the Hawai'i State Archives, mahalo. To Linda Laurence, BJ Short and Patty Belcher of the Bishop Museum Library, thanks. To the staff of the Bishop Museum Archives, Eunice Kane, Marge Kemp and especially DeSoto Brown, mahalo piha.

For invaluable information and mo'olelo, mahalo to Papa Henry Auwae, John Ka'imikaua, Sam Ka'ai and June Gutmanis. Mahalo to my brother Larry Kwiatkowski for computer stuff.

Mahalo also to George Hedemann, Harold Hughes, David Becker, Matthew Pearce and most importantly, Tom Mehau. All of your efforts have made this possible.

PFK

Anuenue pattern resembling fish scales.

Wave or scallop pattern, after drawing by Webber.

▲▲▲

FORWARD

Decorating the body by tattooing is an ancient practice in many areas of the world. In some parts of Polynesia the art developed to its highest degree. The very word, TATTOO, is of Tahitian origin, TATAU, and it means to mark the skin with color. The Hawaiian word is KAKAU.

The first European sailors to explore Polynesia were astounded and intrigued by the tattooed natives they encountered and many of those sailors were themselves tattooed while in the islands. They took home the practice of tattooing and ever since, sailors have been synonymous with tattoos.

Any tattoo is a very personal thing, regardless of the reason it was made. Sometimes the justification for wearing one is deeply ingrained in the cultural tradition of a people, but, as often as not, a tattoo is plainly a decoration and has no meaning other than that which is visually displayed. Certainly there are always underlying reasons for the design chosen by an individual, but a tattoo is basically wearable art.

Some cultures frown upon the practice of tattooing. When tattoos became fashionable in certain gangs and cults, then there was a certain stigma attached to the wearer of the tattoo by virtue of his or her affiliation with that gang or cult. Polynesian tattoos are not about gangs or cults, rather, they are part of the expression of that culture.

This book will explore many aspects of Hawaiian tattooing, its origins and the significance of designs as they relate to religion, magic, social status and just plain fancy. There is no intent for this book to be the definitive work on Hawaiian tattoos, but it is intended to serve as a source of information for those interested in the Hawaiian tattoo. A'ohe ka 'ike apau o ka halau ho'okahi.

Look, read, enjoy!
PFK
Kohala, Hawaii
1996

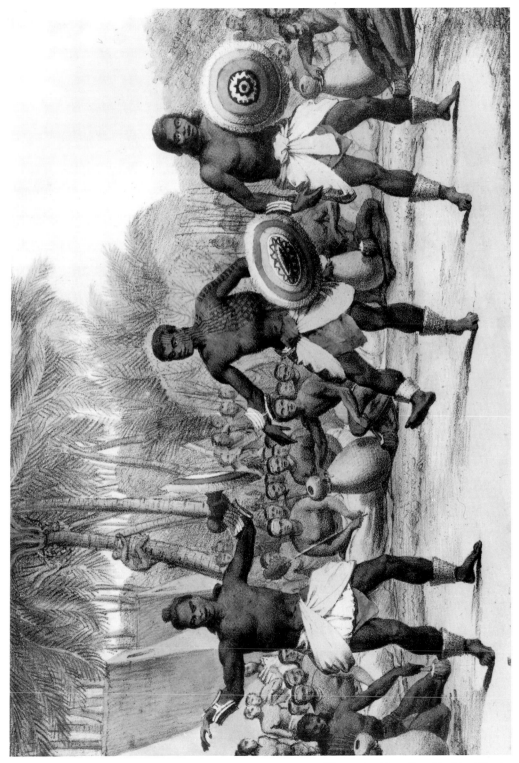

"Dance by Hawaiian Men" by Choris.

▲▲▲

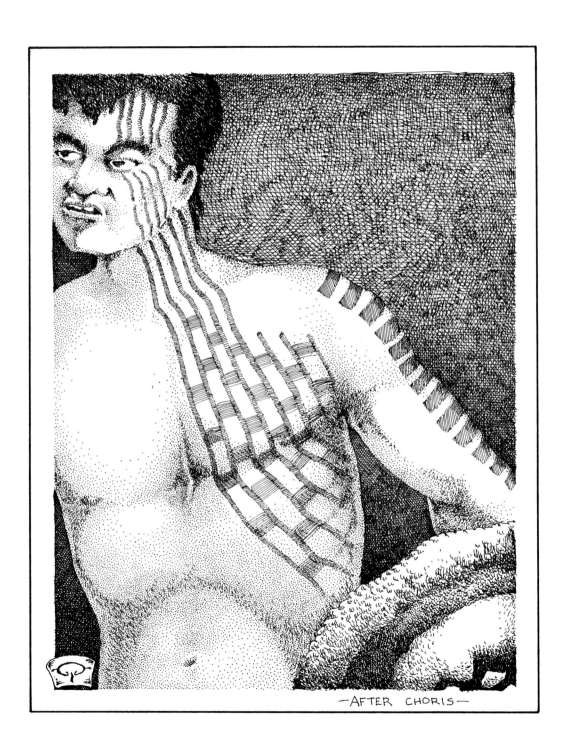

Artist's detail of tattooed dancer.

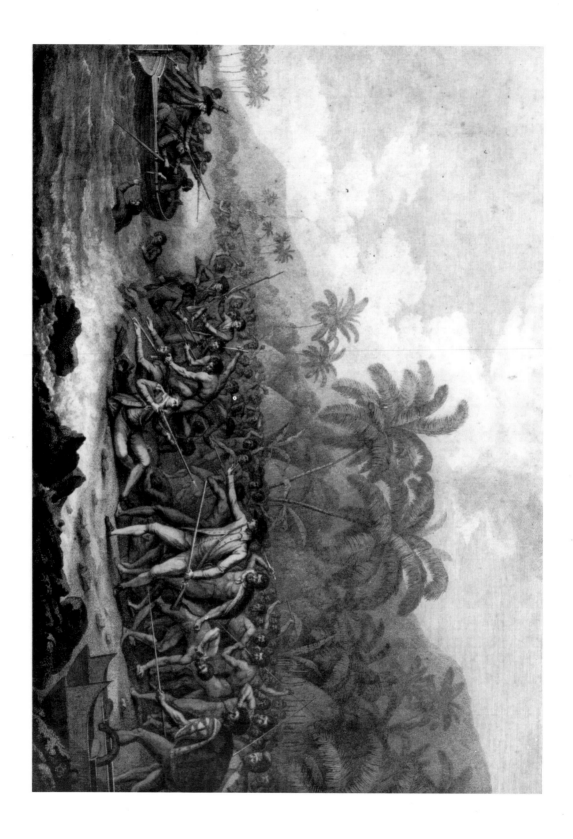

"Death of Captain Cook" by Webber.

▲▲▲

CHAPTER 1

A BRIEF HISTORY OF TATTOOING
Hawai'i and Polynesia

Hawaiian tattooing has its beginnings deep in the history of Western Polynesia. The practice even predates the ancient Tongan and Samoan cultures, the acknowledged predecessors of all Polynesians. Many of the tattoo motifs still present in Tonga and Samoa have similarities to designs from an even earlier culture known as Lapita. The Lapita culture is thought to have had its beginnings in the islands of Fiji and possibly earlier in the area of Papua New Guinea. It is from designs on pieces of Lapita pottery that the similarities to many Polynesian tattoo designs were recognized. It is logical that some of these early designs would have continued into the tradition of the Hawaiian tattoo. The only real significant departure Hawaiian tattooing has made from its early roots, is that the body is less extensively tattooed in comparison to the tattoo practices of Tonga, Samoa, the Marquesas and Easter Island. It is quite possible that early Hawaiians were every bit as heavily tattooed as their Marquesan ancestors, but subsequent arrivals of Tahitians to Hawai'i, who were less tattooed than most Polynesians, probably contributed to the sparser decoration of the body that was witnessed by the first Europeans to set foot in Hawai'i. Further, the tattoo of Hawaii prior to contact with the outside world is primarily composed of intricate combinations of simple linear/geometric designs that contain very few of the freestyle

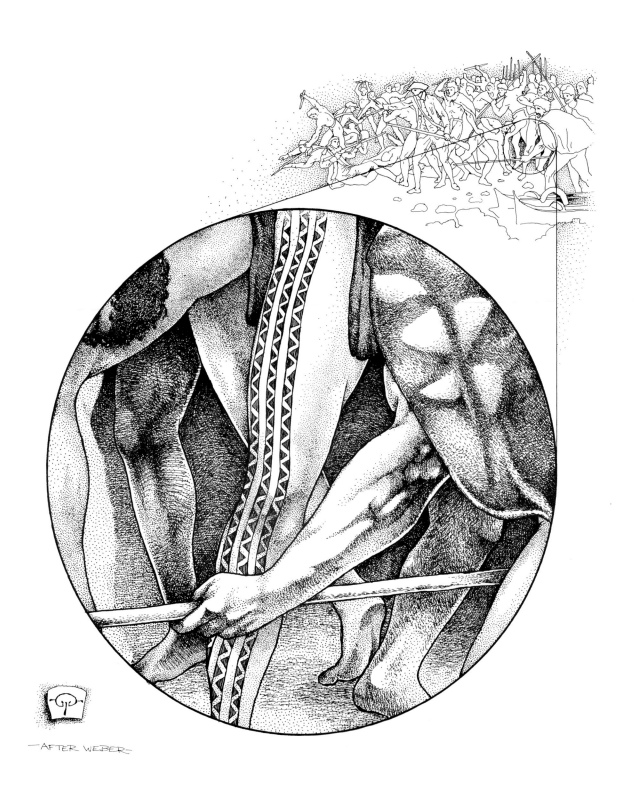

AFTER WEBER

Artist's detail from "Death of Captain Cook."

elements found in the extensive body tattooing in other areas of Polynesia. These intricate and repetitive linear/geometric designs readily identify the tattoo as belonging to Hawai'i.

In some areas of Polynesia, the tattoo was sometimes a factor in identifying to which clan someone belonged. The design could even be broken down further within a clan to identify the particular nuclear family that one was a part of. Whether or not this occurred in ancient Hawai'i is not substantiated, although there have been written references to this practice in Hawaiian publications of recent years.

In most areas of Polynesia tattooing was performed by a priest and was accompanied by certain rituals, chants and ceremonies. Often, these ceremonies and the tattooing were done in a house especially dedicated to tattooing. The priests are called *Tufunga ta tatau* (Tonga), *Tufuga ta tatau* (Samoa), *Tohunga ta moko* (New Zealand), *Ta'unga ta tatau* (Cook Islands), *Tahu'a ta tatau* (Tahiti), and *Tuhuna patu tiki* (Marquesas). It would be a logical conclusion that tattooing in Hawai'i would be performed by a *Kahuna*, but we have no accounts, either in written or oral histories, that such was the case. In fact, it is significant that none of the early explorers to visit Hawai'i ever mentions that a specific individual was designated as a tattoo specialist, though as a rule, a skilled master in many occupations was referred to as a *Kahuna*.

▶ SKETCHES AND LITHOGRAPHS

The earliest recorded evidence that we have regarding Hawaiian tattoos comes to us in the form of sketches and lithographs. These sketches were done by various artists attached to the expeditions of Cook, Kotzebue, and Freycinet, as well as by other amateur artists who visited the islands. There are also logs and journals kept by various individuals that, although not accompanied by sketches, give graphic descriptions of Hawaiian tattoos.

Many of the sketches that were done, in particular those of John Webber (Cook expedition), Louis (or Ludwig) Choris (Kotzebue expedition) and Jacques Arago (Freycinet expedition), were later engraved in Europe to become lithographs. If one wishes to be fairly accurate in the search of pre-contact Hawaiian tattoo designs, then no great emphasis should be placed on the accuracy of the designs depicted in the engravings, unless substantiated by other evidence. The reason for this caution is that many times the engravers, who had never seen Hawai'i or Hawaiians, included tattoos in the lithographs that were not on the original sketches. Whether or not this was done as artistic license or at the later request of the original artist is not known. It may have been that the tattoos were added as an embellishment to make the figures seem more savage or exotic, but this is something we may never know. Therefore, we must rely on the original sketches, graphic descriptions and physical evidence. Kenneth Emory, in his research of Hawaiian tattooing, relied on sketches and, even more importantly, on the mummified remains of Hawaiians in burial caves and

the tattoos that were still intact on the remains. Many of the designs seen on the remains had already been recorded in sketches and engravings, thus establishing their authenticity.

A further distinction must be made as to which designs were in use prior to contact with the outside world and which designs were popular after contact. Most often the pictorial accounts of Webber (1778) can be the only reliable references to pre-contact designs. Those who came later, notably Choris (1816-1817) and Arago (1819), certainly included pre-contact motifs in their sketches, but most of their illustrations contain post-contact motifs.

As a general rule, one might say that the majority of pre-contact tattoos consisted of geometric designs and the majority of post-contact tattoos consisted of pictorial themes (goats, guns, names and dates, etc.). In his manuscript on Hawaiian Tattoo Motifs, John McLaughlin cites 26 examples of goats used in sketches or engravings showing Hawaiian tattoos. The vast majority of pre-contact Hawaiian tattoos utilize geometric motifs.

► HISTORICAL ACCOUNTS

Early European visitors to Hawai'i noted that the Hawaiians were tattooed to a lesser degree than Polynesians in the Western Pacific, (Tonga, Samoa, Tahiti, and New Zealand). The following are excerpts and quotes from the journals and logs of various visitors and artists;

A description of the ruling chief of Maui (Kahekili) is given in the journal of the surgeon of the HMS Resolution, David Samwell, who accompanied Cook; "He himself, is a middle aged man, is rather of a mean appearance, the hair on each side of his head cut short and a ridge left on the upper part from the forehead to the occiput, this is a common custom among these people, but each side of his head where the hair was off was tattooed in lines forming half circles which I never saw any other person have." It is interesting to note that Samwell never made any reference to Kahekili having half of his body completely tattooed (termed *pa'ele kulani*), which has been a common assumption of most Hawaiian historians, but which may stem from the fact that the Hawaiian god of thunder, Kahekili, was described as having half of his body tattooed from head to foot. Certainly if Samwell had observed this most obvious of tattoos upon the body of chief Kahekili, he would have made mention of it.

Captain Cook's surgeon, William Ellis (not to be confused with the later arrival, missionary Rev. William Ellis), reported, "The custom of tattooing prevails greatly among these people, but the men have a much larger share of it than the women; many (particularly some of the natives of Mowwhee) have half their body, from head to foot, marked in this manner, which gives them a most striking appearance." What is of particular interest when discussing Hawaiian tattoo practices, is that it did not seem to matter whether one

was a commoner or a chief in order to obtain and wear a tattoo. Economics was a factor as to whether or not one could afford to pay for the services of an expert tattooist, meaning that the poorest of the poor would not have worn many tattoos at all. In many of the sketches by Webber and Arago the persons depicted as having many tattoos seemed to be hula dancers, both male and female.

In 1819, Jacques Arago observed that Ka'ahumanu was tattooed and he recorded that her "legs, the palm of her left hand, and her tongue are very elegantly tattooed." Arago also reported men from O'ahu, "tattooed only on one side, which produced a very singular effect; they looked just like men half burnt, or daubed with ink, from the top of the head to the sole of the foot." This type of solid black tattooing of half the body is called "*pahupahu*" by Hawaiian historian Samuel Kamakau. It is also believed to have been a tattoo that was somewhat restricted in its use, in that it was only seen on warriors. This type of tattoo was common among the warriors of the Marquesas Islands. W.C. Handy, who visited the Marquesas in the early 1920's, obtained information as to why the Marquesan warriors tattooed themselves in this manner. It was explained to her that it was a form of disguise, in that the tattooed half of the body was shown to the enemy in combat in order that the warrior not be recognized by an enemy in future encounters. It is unknown whether or not the Hawaiian warriors that were tattooed in this manner had a similar purpose. There are phrases in the Hawaiian language that refer to tattooing, but no chants that I am aware of have survived, if indeed, any existed. That chanting may have been a part of the process of tattooing is evidenced by tattooing chants that have survived from elsewhere in Polynesia. The following are examples of tattooing chants;

Marquesas:

> *Ua tuki e, ua tuki e, ua tuki e, ua tuki a,*
> *to tiki e,*
> *Poparara to tiki e,*
> *O te tunane o te kui a,*
> *O te tuehine o te kui a,*
> *To'u tiki e.*

> *It is struck, it is struck, it is struck,*
> *it is struck, your design,*
> *Tap tapping your design,*
> *The brother of the mother,*
> *The sister of the mother, My design.*

New Zealand:

Te tangata i te whakautu,
Kia ata whakanakonako,
Tangata i te whakautu kore,
Kokia, kia tatahi....

He who pays well,
His marks will be remembered,
He who does not pay well,
His lines will be far apart.

Samoa:

E isia le 'ula, isia le fau,
'A e le isia siau tatau,
'O siau 'ula tutumau,
E te alu ma 'oe i le tu'ugamau.

The necklace breaks, the cord breaks,
But your tattoo does not break into pieces,
This necklace is forever,
And goes with you to the grave.

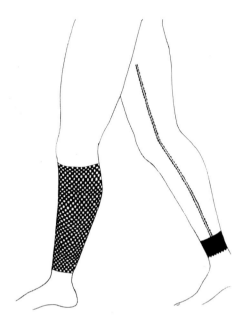

a. Hawaiian tattoo designs on female mummy. Bishop Museum photo.

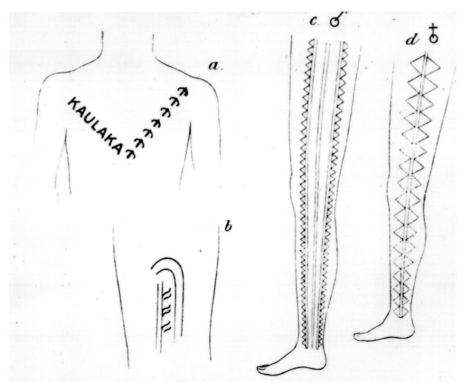

b. Tattoo on Hawaiian man described by Kramer as *Koa'e* birds. Bishop Museum photo.

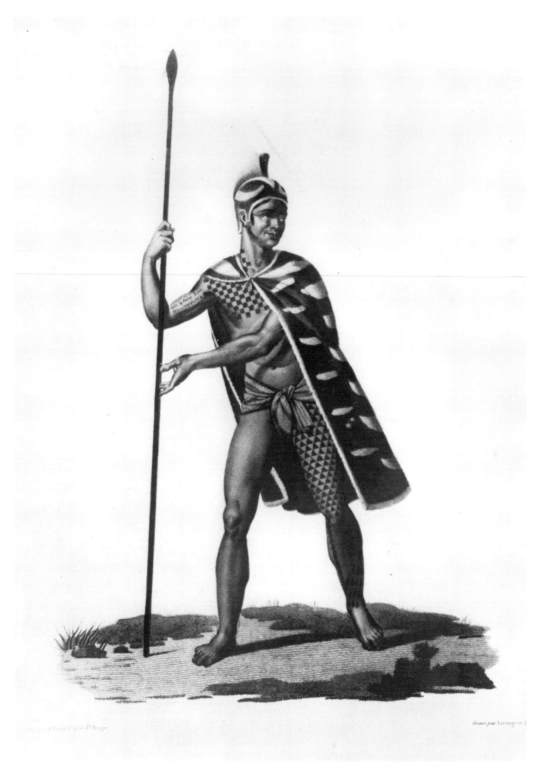

"Hawaiian Officer" by Arago. Hawaii State Archives photo.

CHAPTER 2

▶▶ TECHNIQUES AND TERMINOLOGY

Hawaiian tattooing instruments are similar in design and function to those of other areas of Polynesia, but much information has been lost regarding the names by which they were called and whether or not different needle materials caused the needles to be called by different names. No one apparently recorded the Hawaiian name of the mallet used to strike the tattoo needles. In the Hawaiian Dictionary (Pukui-Elbert), the word *ku'au* is given the meaning "a mallet used for beating". Emory stated that the term *hahau* might describe the mallet, but the word is translated in Pukui-Elbert as "to strike". It is possible that Emory had found that the word *hahau* is very similar to the Samoan word *sausau*, which is the term for the mallet in the Samoan language. Emory quoted an excerpt from the Andrews-Parker dictionary thus, *"Hahau iho la ka moli, pahuhu a'e la ke koko,"* which means "The tattoo needle is struck, the blood oozes out". Here the term *moli* is used to identify the needle. In the Hawaiian Dictionary *moli* is translated as "1. Laysan albatross (*Diomedea immutabilis*). 2. Any straight line separating designs in tattoo pattern. 3. Bone made into a tattooing needle, hence a tattooing needle." Emory also concluded that certain bones of the albatross may have been used to make the needles, thus the use of the name of the bird to identify the needle.

The Hawaiian word for tattoo markings is *uhi*. The Andrews-Parker dictionary defines *uhi* as "a mark left by dye on the body or on tapa". The terminology used in applying a

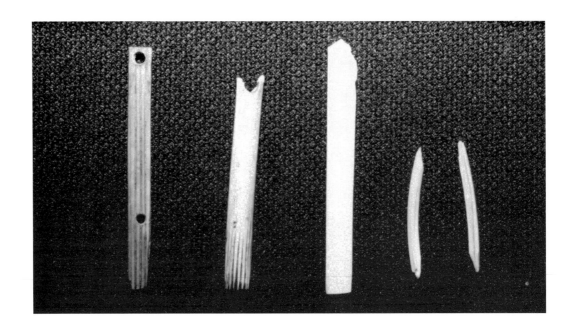

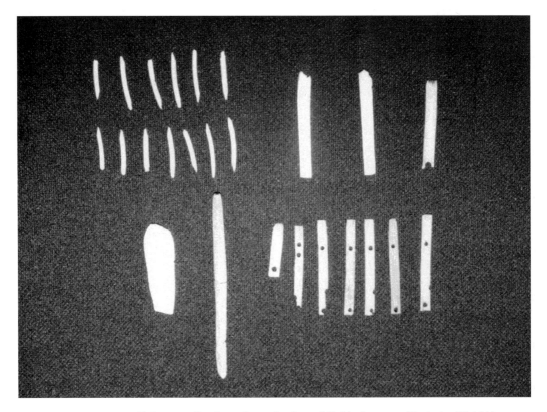

Tattoo needles from the collection of G. Hedemann. Photo by Michi Hanano.

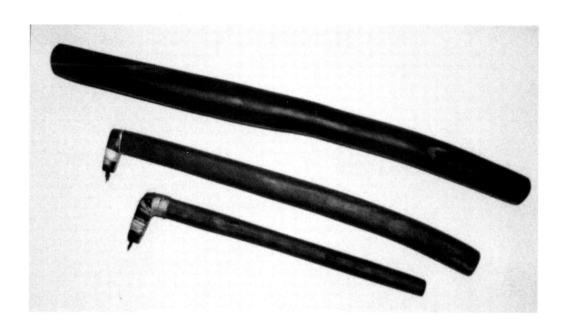

a. Author's homemade tattoo needles. Author's Photo

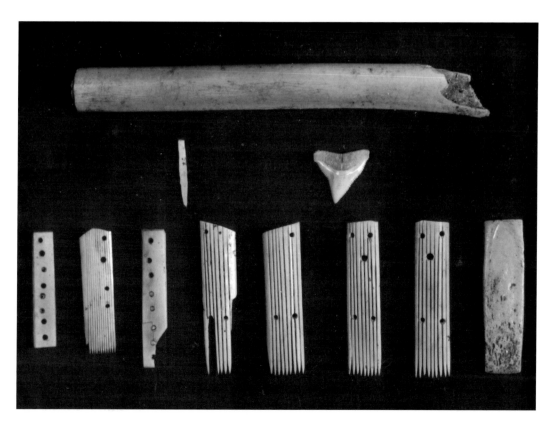

b. Ancient Hawaiian tattooing instruments. Bishop Museum photo.

▲▲▲

tattoo is called *kakau*, thus the phrase "*kakau i ka uhi*" describes the "tattooing of the mark".

The pigment from which tattoo ink, or *pa'u*, was prepared was most commonly obtained from the burnt remains and soot of the kukui nut (*Aleurites moluccana*). In 1819 the artist Arago noted that the coloring matter was mixed with the combined juices of the coconut and sugar cane. This was probably done to give the mixture a heavy consistency so that the ink, when entering under the skin, did not "bleed" or run outside the desired area. The soot of the kukui nut was obtained by burning the kernels in an enclosed fire surrounded by rocks. A smooth flat stone was placed atop the fireplace rocks directly above the burning kernels in order for the soot to collect on the surface of this flat stone. The soot could then be scraped off and the mixture made. It is an intense black which stains anything it comes in contact with.

Another tattoo pigment was described by Otto Degener in his book <u>Plants of Hawai'i National Parks</u>, as the mixed juices of the leaves of the *mau'ula'ili*, the Hawaiian iris (*Sisyrinchium acre*) and the fruit of the *popolo-ku-mai*, the Hawaiian pokeberry (*Phytolacca sandwicensis*) not to be confused with the popolo of the species *Solanum*. It is unknown who Degener's informants were in regards to this mixture, but it is included here for its informative value. Also of interest is the wild plumbago (*Plumbago zeylanica*), or *'ilie'e*, a climbing plant whose juices were used in ancient Hawai'i to darken tattoo marks immediately after the process was completed. As a note of caution, most plumbagos, even though used medicinally, are mildly poisonous.

There are also vague references to fish bones used in the tattooing process, but that is all the information one usually comes up with. In an interview with Papa Henry Auwae, a noted *kahuna la'au lapa'au*, or herbal healer, the uses of fish bones was explained to me. Papa Auwae described the use of the knifelike tail bones of three Hawaiian fishes to make tattoo needles. These were the Palani (*Acanthurus dussumieri*), the Kala (*Naso unicornis*), and the Pualu (*Acanthurus mata*). The barbs were slit from the point a short way down to form a double point. Other grooves were made from the base towards the points in order to feed ink from the base to the tip. The base was wrapped with the fibers of the *olona* (*Touchardia latifolia*) and this wrapping provided a reservoir of sorts to feed ink to the needle point. This barb was then attached to a stick which was struck with a mallet in the old method. Multiple needles could be lashed together to form a composite needle to cover large areas of design. Papa Auwae also stated that the bones of these fish were used to make an ink for tattooing. The recipe was that the bones of only one fish were used, shavings of *Iliahi* (sandalwood) were placed atop the bones and kukui nut oil was dropped onto the shavings and then set afire to char the bones. Once the bones were black enough they were pounded into powder and to this the juice of the cleaned and pounded root of the Neneleau (*Rhus sandwicensis*) was added along with a few drops of salty seawater (taken from a place where not too much fresh water entered the sea). He also mentioned that a dye for tattooing can be obtained from the blackened ash of the pounded bark of the Neneleau root. The root was cleaned and dried, kukui oil was added and the mixture was burned to form the main ingredient.

It is also noteworthy that the Neneleau was also used in the tanning process, as it does contain a large amount of tannin. In addition to fish bone tattoo needles, another type of needle described by Papa Auwae was made of the beaks and claws of certain Hawaiian birds. This can be substantiated by the fact that a tattoo needle set in the collection of G. Hedemann contains 13 bird beaks as well as other incised and cut bones.

Arago also described a similar tattoo implement and its use; "They fix the bone of some bird to a stick, slit the bone in the middle, so as to give it two or three points, which they dip in a black colour...they apply these points to the part to be tattooed, and then they strike gently on the stick to which the bone is attached, with a wand, two feet in length." A description of a tattooing mallet in the collection of the Peabody Museum gives the length of it as 7.9 inches, and might be closer to the actual measurement than the two feet described by Arago. How the needles may have been struck is unknown. Whether they were struck as a single blow or numerous taps is not recorded. If one were to observe old techniques still in use in Samoa, one would find that a rapid series of taps is used. A pillow is sometimes used for the stick that the needles are attached to in order to steady the stick in one place.

By varying the amount of teeth on any particular needle it is easy to see how the sizes of certain designs could remain constant and uniform. If a needle were a quarter of an inch wide, it could then produce regular quarter inch patterns such as triangles, rhombs or squares, all a quarter inch long on the sides. If a long straight line was desired, it would also seem more probable to use a needle with a greater amount of teeth, which would make the task easier and allow for better alignment. A most interesting needle in the collection of G. Hedemann of Kailua-Kona is a single bird bone that was incised to make needle points around the entire end circumference of the bone, thus creating a circular pattern tattoo needle with which circular tattoos could be struck in a single blow. Also included in this same collection are a number of bone needle points designed to be joined together in order to color a large area of tattoo, and the 13 bird beaks with must have been used as single needles for fine detail work.

☛ PRESENT DAY TECHNIQUES

Modern day do-it-yourself tattooists normally use black India ink for their tattoos. I have made and used the ancient mixture of kukui nut soot, ashes and sugarcane juice with some interesting results. I found that the color comes out a true black when injected under the skin, but when the resultant scab sloughs off, it turns a shade of blue, much the same as India ink. Perhaps this is why the ancient Hawaiians used the juice of the *'ilie'e* to darken the tattoo pigment.

The most popular home made tattoo instrument is a single sewing needle to which a thread is wrapped around many times about 2-3 mm from the tip. This provides a sponge

or reservoir that can hold ink. When the skin is punctured to the 2-3mm depth, the thread holding the ink makes contact with the skin and releases a small amount of ink into the same puncture as the needle. This is a very precise, but time consuming, method and is normally used in smaller tattoo designs. I made an interesting variation of this type of needle after first failing to recreate an ancient type of tattoo needle made of ivory. I believed ivory would be an ideal substitute for albatross bone, but after experimenting and having the tips of the ivory break off under my skin, I abandoned this idea. Instead, I sandwiched a row of four evenly spaced sewing needles between two small pieces of wood and then I attached a wooden handle to the needles that covered them at the top at right angles. Some thread was then wound around the tips of the needles until about 2-3mm was left exposed at the tip. I have used this needle with good success and it is used in the ancient manner by tapping with a mallet and dipping into ink. I find that, in comparison to electric tattoo needles I have experienced, this combination of needles is less painful, although painfully time consuming.

Another type of tattoo needle that has found widespread use in prisons is a needle made from the cut off section of a metal guitar string (needles are not allowed in the hands of prisoners). The needle is sometimes attached to the end of an electric engraver, thus producing a jerry-rigged version of the electric tattoo needle.

The obvious choice of most modern day tattoo artists is the hollow electric tattoo needle. It is a speedy and precise way of applying tattoo designs and is in use the world over.

► WEARING THE DESIGN

Although it is a general statement that tattoos can be placed just about anywhere on the body, there were some aesthetic considerations that pertained to Hawaiian tattooing. Placement of the design was not required by strict rules, but dictated instead in the interest of symmetry. This can be seen in many examples where a balance was obtained by the placement of a tattoo on one side of the upper body and then on the opposite side of the lower body. This is to say that, if a tattoo was placed on one's right shoulder and arm, then one might place additional tattoos on the left thigh and leg to strike a balance. In some old Hawaiian lithographs, however, many tattooed persons are depicted as having tattoos randomly placed on all areas of the body. These lithographs are mostly post-contact lithographs and contain a great many non-Hawaiian elements (guns, goats, etc.).

Women seemed to have the majority of the types of tattoos that were worn on the fingers, hands and wrists. There were even designs that were placed on the palms of the hands (ouch!). Hawaiian historian John Papa I'i mentions that those persons who chanted for the hula and beat the hula gourd drum (*ipu* or *ipu heke*) had the left hand "beautifully tattooed, because that was the hand that held the cord attached to the drum through a hole." Women also wore the majority of tattoos found on the ankle and lower calf. These types of tattoos were usually formed into bands that either covered a small area, somewhat like

an anklet, or entirely covered the calf. These band type tattoos were also worn by women on the wrist, either alone or as part of a hand design. As far as research can determine, arm band type tattoos were not a Hawaiian concept, but they are enjoying great popularity in present day tattooing.

Facial tattooing was practiced in Hawai'i, but it utilized the more photogenic areas of the face for display purposes. The brow ridge, the cheek and cheek bone and the chin were the more common areas on which facial tattoos were made, and unlike other areas of Polynesia, rarely were the lips and areas around the mouth tattooed. The tongue, of course, was tattooed on both men and women in Hawai'i as a sign of grief.

As far as research can determine, there is an apparent absence of tattoos placed on the back. There are only a few sketches of lithographs that show tattoos on the back (one by Webber and one by Arago). What reason there could have been for this remains a mystery, but it may have stemmed from typical politeness. Hawaiians of old considered it rude to turn the back on someone, and to show a tattoo on the back would have required this to be done.

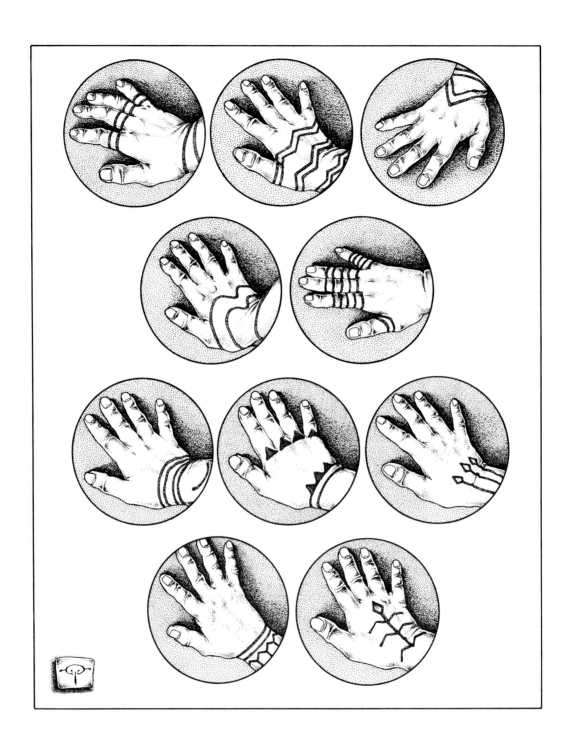

Artist's rendering of female hand tattoo motifs after a drawing in K.P. Emory's Hawaiian Tattooing, BPBM Occasional Papers, 1946.

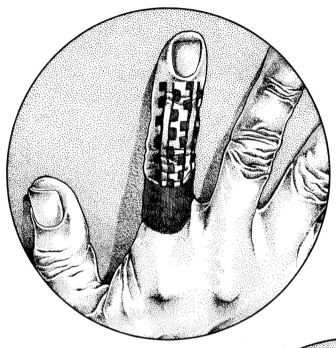

a. Finger design from a Hawaiian female (mummified remains).

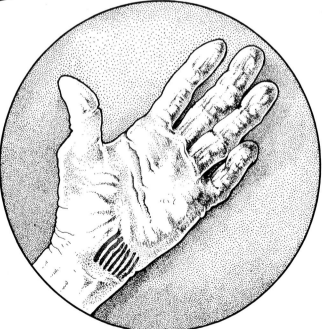

b. Palm tattoo from a Hawaiian female (mummified remains).

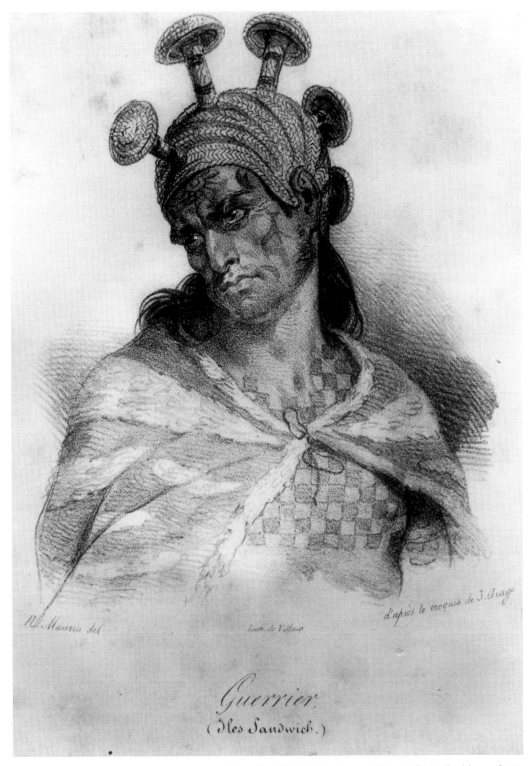

Guerrier
(Îles Sandwich.)

"Hawaiian Warrior" by Arago. Hawaii State Archives photo.

CHAPTER 3

▶ TATTOO DESIGNS AND THEIR RELATIVES

One of the first things I realized while researching Hawaiian tattoo designs, is that there really is not much information regarding the names of many of the designs. True, there are obvious representations that one can place in generic categories such as birds, human figures, animals and fans, but many of the geometric designs have no known designation specific to the art of tattooing.

Certain tattoo designs have been identified for us through various sources. In one case Augustin Kramer, while researching tattoos in Hawai'i in 1899, had two tattoos identified for him, one of those being the *koa'e* bird design and the other a double linear design that he was informed was called "*ala nui o Kamehameha*", or the road of Kamehameha.

If one were to carefully search the Hawaiian Dictionary, there are names for designs with descriptions such as the following: *MA'OI'OI* (zigzag), *KIKO* (tattoo with dots on the forehead), *KIKIKO* (to tattoo with dots and spots), *PA'ELE* (solid black tattooing without design), *PA'ELE KULANI* (solid black tattoo without design, but on one side of the body only), *HIKONI* (tattoo brand on the forehead of the kauwa, or slaves). *HIKONI* was also a tattoo used to mark the seducer of a chief's wife. *MAKA UHI* (a tattoo on the inner part of the eyelid; a defeated warrior was tattooed in this manner as an insult so that, waking or sleeping, he would always be reminded of his defeat). These are but a few examples where tattoos or tattoo types have specific names, but it is far easier to look elsewhere for

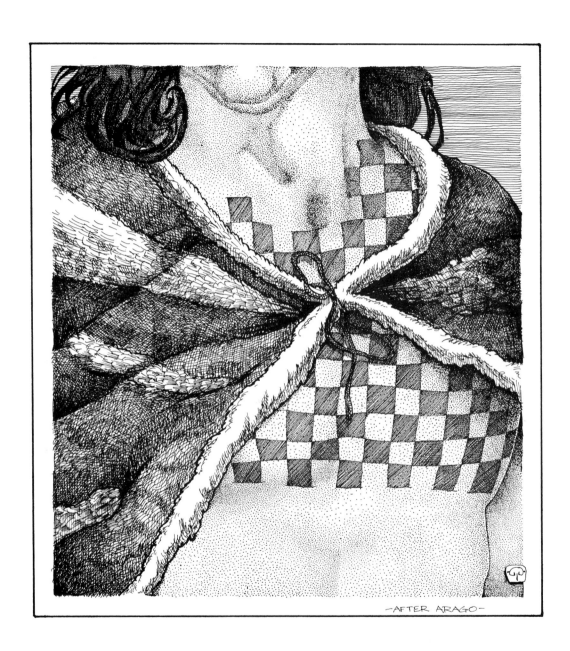

—AFTER ARAGO—

Artist's detail of checkerboard or "papa konane" pattern.

motifs whose names have been recorded in other areas of Hawaiian art, craft or custom.

Early on, I realized that there were striking similarities in the geometric patterns on tapa stamps and their counterparts in tattooing. This type of similarity was also noted by anthropologists who studied the design patterns on Lapita pottery shards as compared with Tongan and Samoan tattoo designs. The similarities were also obvious to Emory in his research and he cited many examples where tattoo patterns were directly associated with, or taken from, the patterns on tapa stamps or beaters. Since tapa designs were well documented and were identical to certain tattoo motifs, I have listed some of them as a possible source of identification. This does not mean that they carry the same name in both practices, rather it shows what names Hawaiians of old associated with certain distinct patterns.

There is a tapa design that is called *"ko'eau"* (gently waving parallel lines, literally "moving worm") and the identical design is used in tattoos. We cannot say that the tattoo design is called *"ko'eau,"* but we at least know what the design is called when it is used in the making of tapa. There are also assemblages of triangle designs which are found on tapa beaters and stamps and are called *"niho mano"* or shark teeth. It would seem to follow that the identical design in tattooing should have the same name.

Other tapa designs that have identical counterparts in tattooing are: *KAPUA'I KOLOA* (resembling duck tracks), *'ANUENUE* (a scallop-like design), *NIHO WILI HEMO* (zigzag stripes), *'UPENA* (a net pattern), *KONANE* (a checkerboard pattern), *LEI HALA* (a design like blunted spear points connected base to point, either vertically or horizontally), and the list goes on.

We may also rely on the design designations of makaloa, or Ni'ihau mats that have look-alikes in tattooing such as *NENE* (paired triangles stacked base to point and resembling geese in flight), *PUAKALA* (triangles in a row, bases and tips touching) *HUMUNIKI* (squares joined at their points in a row), *KAHANU* or *KUHANU* (paired rows of triangles facing each other and touching at the tips). Many times the names used to identify the designs on the mats are identical to the names by which the same tapa designs are called. It is for this reason that there is a strong possibility that the same names applied to the identical designs in tattooing.

Another useful comparison to make is to check the designs that appear on Hawaiian gourd containers and whistles. These gourd designs feature the same elements common to tapa, makaloa mats, feather capes, and of course, tattoos.

A rare depiction of a design that has its counterpart in tattooing is that of lizards painted on the face of a wooden image in the Bishop Museum. The image is identified as a Kalaipahoa, or poison god used in sorcery. There are lizard figures on either side of the chin, on each cheek and above both eyebrows. The designs on this image closely match the description of lizard tattoos as described to John Stokes in 1919. Stokes interviewed a man of Honaunau named Lo'e, who told of the genealogy of the Keawe'ai family and the fact that a certain Keawe'ai was voluntarily sacrificed at the dedication of the Hale O Keawe heiau. He mentioned that this Keawe'ai had tattoos of lizards "two on the eyebrows, two

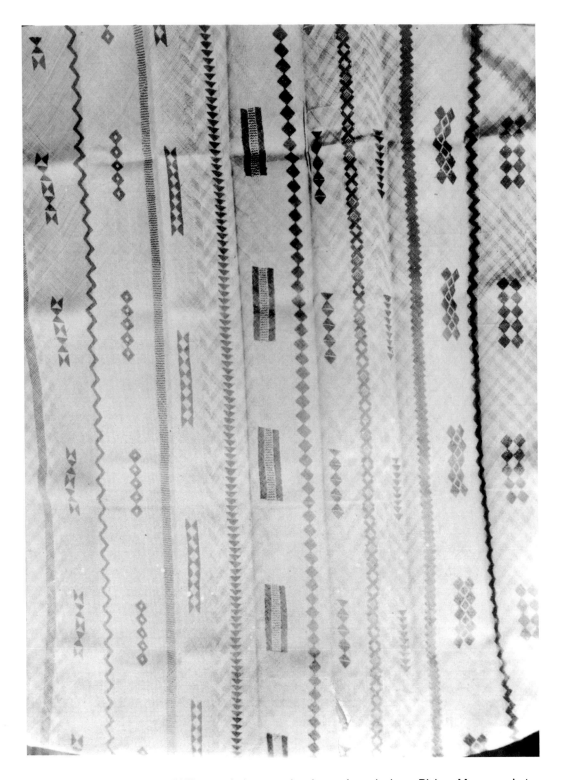

Portion of Niihau makaloa mat showing various designs. Bishop Museum photo.

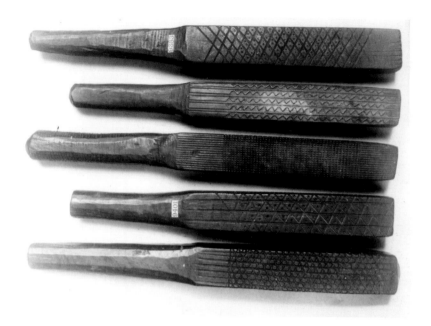

a. Hawaiian kapa beaters with 'upena, ko'eau and niho mano motifs.
Bishop Museum photo.

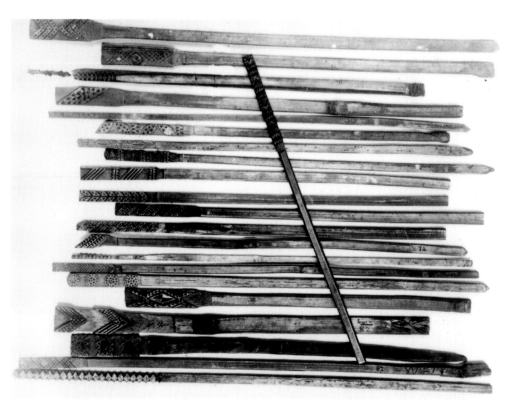

b. Bamboo tapa stamps. Bishop Museum photo.

▲▲▲

on the cheeks and one on the chin." What is most interesting is that this Keawe'ai was a resident of the island of Hawai'i, and the Kalaipahoa image that bears the lizard designs was found in a cave above Waimea Valley, O'ahu.

Lastly, other forms of designs that can be linked to tattooing can be found in Hawaiian petroglyphs. We can document petroglyphs of human figures, birds, such as owls and tropic birds, goats, lizards, fans, spirals and guns, all of which can be found in tattoo designs.

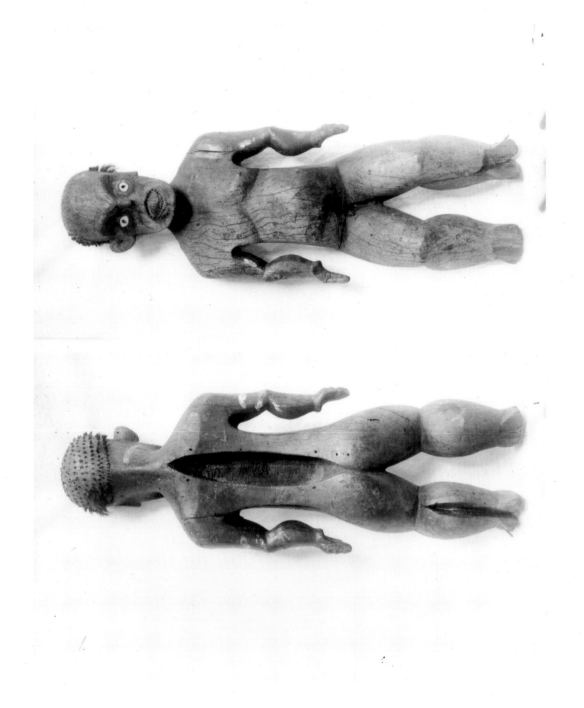

Kalaipahoa, or poison god image with lizard tattoo motifs on the face. Bishop Museum photo.

▲▲▲

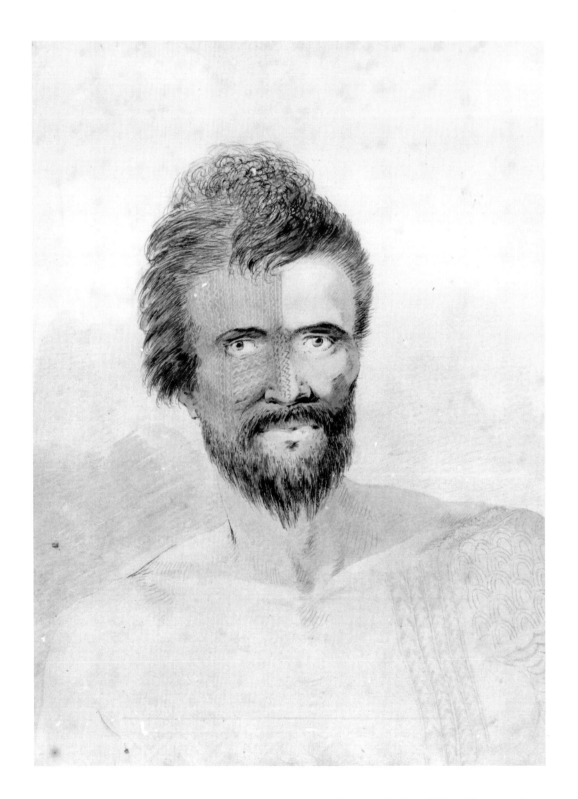

"Hawaiian Tatooed Man" by Webber. Bishop Museum photo.

CHAPTER 4

BASIC GEOMETRIC DESIGNS

As noted in Chapter 1, the majority of Hawaiian tattoos consist of geometric designs. These designs contain elements that are universal, as well as specific to Hawai'i, in the manner in which they were assembled into unique patterns, although their origins are most probably linked with the previously mentioned Lapita designs and motifs.

Those designs that can be classified as universal include straight lines, circles, semi circles, rhombs, squares, triangles, bars and crescents. It is the varied and artistic way that these geometric figures are used to form distinct patterns that make them readily identifiable as Hawaiian designs. The purpose of this chapter is to visually display the variety of ways that different geometric elements can be displayed and assembled to form unique motifs.

Niho Mano variation

Design designated as "Ala Nui O Kamehameha" by a leper
on Molokai as told to Augustin Kramer in 1899

Bird motif with rows of connected triangles after a tattoo from the arm of a mummified female.

Niho Mano, Pyramid Style

Niho Mano, Linear / No Border

Niho Mano Pattern
Single Strand

Liholiho Pattern

after drawing of dancer by Choris

Bar Design
after drawing of dancer by Choris

Various designs, combining niho mano elements.

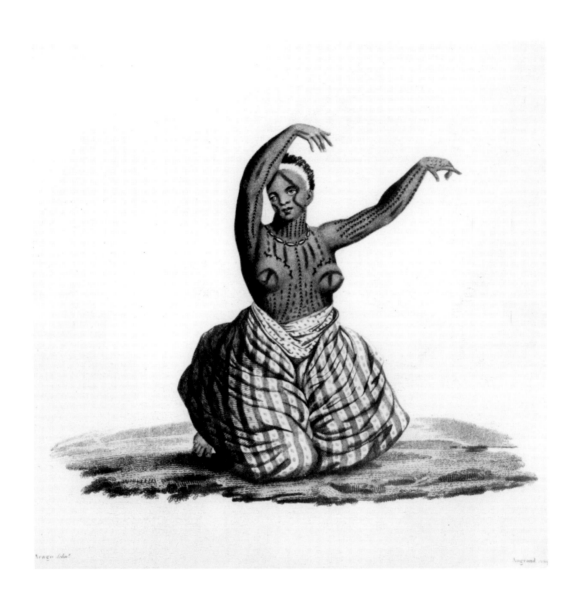

"Maui Woman Dancing" by Arago. Hawaii State Archives photo.

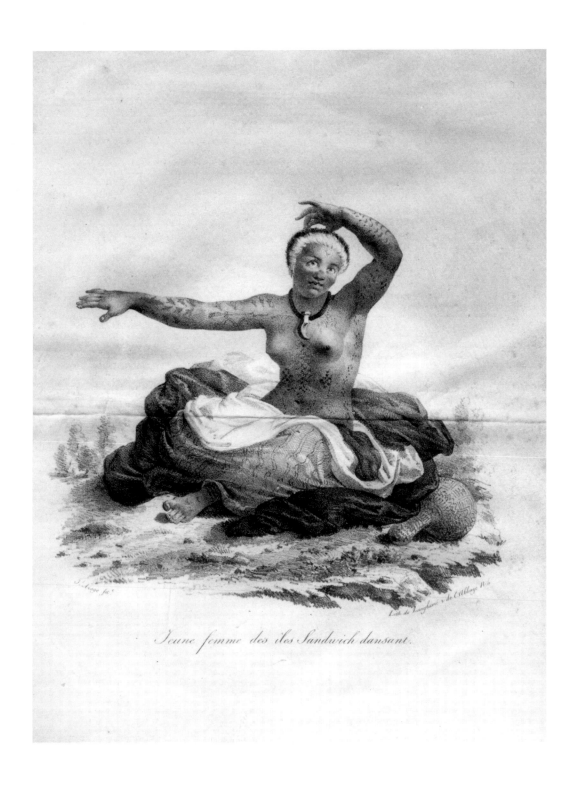

Jeune femme des îles Sandwich dansant.

"Young Woman of Hawaii" by Arago. Hawaii State Archives photo.

Artist's detail of lizards on the face of Kalaipahoa image in the Bishop Museum.

CHAPTER 5

THE ʻAUMAKUA

Oral traditions tell us that certain tattoo designs were connected with the ʻaumakua of the individual who wore the design. ʻAumakua, as defined in the Hawaiian Dictionary, is a family or personal god. Interestingly enough, no further elaboration is made as to what or who constituted an ʻaumakua. The very concept of ʻaumakua is not easy to explain, although a parallel might be seen in the use of certain American Indian totems. ʻAumakua are useful, protective, and benevolent as well as destructive and mischievous, depending on which side of the power of the ʻaumakua you happen to be on. Many Hawaiian families of today maintain their traditional belief in their ʻaumakua and still recognize and pay homage to them. ʻAumakua can take many forms, that of a spirit, an animal, an inanimate object such as a stone or gourd, or an ethereal thing such as thunder. Most ʻaumakua are passed on within the family from generation to generation, and in this way some families may claim a few dozen different ʻaumakua, although the emphasis on which are most effective and familiar relegate the others to mere stand-by status.

A good example of an ʻaumakua relationship and the resultant tattoo is related in a story about a woman who was bitten by a shark. In 1923, Lorrin Thurston mentioned to Kenneth Emory that he had seen women tattooed with a row of dots around the ankle as a charm against sharks. This practice stemmed from an ancient story of a woman who went swimming and was bitten by mistake on the ankle by a shark that happened to be her ʻaumakua.

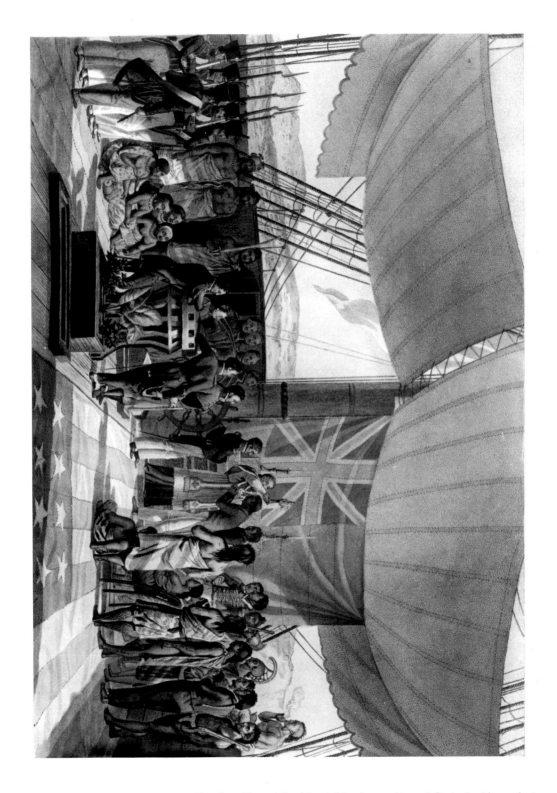

"Baptism Aboard the Uranie" by Arago. Hawaii State Archives photo.

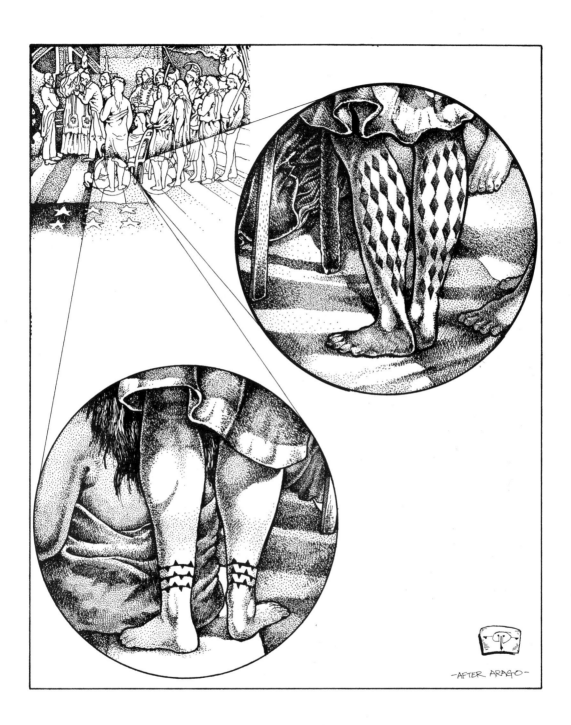

Artist's detail of ankle and calf tattoos.

When she cried out his name, he let go, saying "I will not make that mistake again, for I will see the marks on your ankle." Even to this day, there are many Hawaiians who know certain sharks as their *'aumakua*, and there are even the rare individuals who are skilled at calling sharks to them, much as one would call a puppy to be petted or fed. It might be pointed out that not all sharks were considered *'aumakua*. The ancient Hawaiians also recognized certain sharks as man-eaters, *niuhi*, and they hunted these sharks for sport as well as for the skins and teeth they provided.

But the *'aumakua* are not just guardians or protectors. Certain kahuna used their *'aumakua* as helpers in the practice of sorcery. Other *kahuna* used their *'aumakua* to charge their medicinal potions with mana, or power, to increase the effectiveness of their herbs and rituals. As stated before, *'aumakua* come in all different forms and some of the tattoos worn by Hawaiians directly related to their *'aumakua*, as in the case of lizards, certain birds, or elements that represented the *'aumakua*, such as some of the *niho mano* designs.

I don't believe a complete list of all the *'aumakua* could ever be made, but some of them include *mano* (sharks), *honu* (turtles), *lanalana* (spiders), *mo'o* (lizards), *'io* (hawks), *pueo* (owls), *'alala* (crows), *he'e* (octopuses), *loli* (sea cucumbers), *'ope'ape'a* (bats), *'enuhe* (caterpillars), *'opihi* (a limpet), *pinao* (the dragonfly), certain trees, gourds, thunder, lightning and even specific stones, either carved or found in nature.

In days of old, if someone did not have an *'aumakua*, offerings and prayers were made to the *'aumakua* with which one wished to be associated. When favorable signs were shown to the individual by the intended *'aumakua*, then that particular *'aumakua* became *'aumakua* to that person and to that person's family. If the *'aumakua* were neglected, however, then ill fortune could befall the family as a result of the actions of the offended *'aumakua*.

There are many stories of old Hawai'i that tell of the intervention of a family *'aumakua* to avert disaster or accident. Stories of a fisherman being capsized at sea and in danger of being drowned, when out of nowhere appeared the shark *'aumakua* to give him a ride to shore. There is even a popular song that includes reference to an *'opihi 'aumakua* who overcomes a monster eel by covering its eyes. The story behind the song is that a young girl was kidnapped by a giant eel and her brother went to various animals to ask for their assistance in rescuing his sister. The response from each animal, except the *'opihi*, was that the eel was much too big for them, but the *'opihi* said that he could help. The *'opihi* went to the giant eel's cave and jumped onto its slimy body. Using its suction-like grip, it made its way to the eel's eyes and covered them, thus allowing the girl's brother to enter the cave and rescue her.

Incidents involving *'aumakua* occur today and are shared with others who still maintain their belief in the *'aumakua*. I will tell you of an incident that occurred to me late one night as I was driving home from Kailua-Kona on the Mamalahoa Highway. As I was nearing the intersection at Waikoloa, a dense fog began to appear on the roadway ahead of me. I slowed a bit and soon I saw a pair of glowing eyes ahead of me, but far too late too avoid striking whatever it was. I realized that I had struck a *pueo*, a Hawaiian owl, and that

it had entangled itself in my passenger side outside mirror. I pulled over to the side of the road and was extremely pained to see that I had caused the death of this *pueo*, which happens to be one of my *'aumakua*. I apologized and placed it off of the side of the road and covered it with an *ahu*, or stone cairn. As I continued on my way I came upon a traffic accident at the Waikoloa intersection that had apparently just occurred. I believe that by stopping to bury the *pueo* that flew up in front of my truck, I was prevented from being involved in that accident. Coincidence? Maybe and maybe not. There are many other stories of today that could be told with regard to *'aumakua*, but the purpose of this chapter is not to validate anyone's belief, but to give one a glimpse into the function and purpose of certain tattoos as they pertain to *'aumakua*.

It is also important to note that certain *'aumakua* have names and that some *'aumakua* tattoo designs can and probably should have names. The two *'aumakua* that are most readily identified by names are *mano* (the shark) and *mo'o* (the lizard), not your everyday household gecko, but a large dragonlike entity. Depending on one's genealogy, one might be able to actually identify by name their particular family *'aumakua*. Some of the more prominent shark *'aumakua* are listed as follows; Kamohoali'i, Ka'ahupahau, Ka'ehuikimanooPu'uloa, Kahi'uka, Kaholia Kane, Kua, and Kane'apua. Some *mo'o* *'aumakua* are; Mo'oinanea, Kihawahine, Kihanuililumoku, Hauwahine, Kaikapu, Kalamainu'u, and Waka. Two of the more famous owl *'aumakua* are identified as Kukauakahi and Pueokahi.

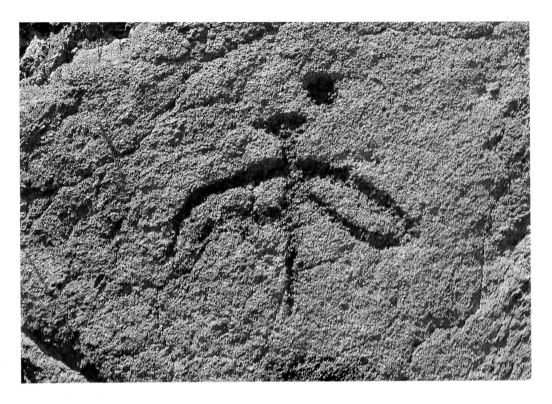

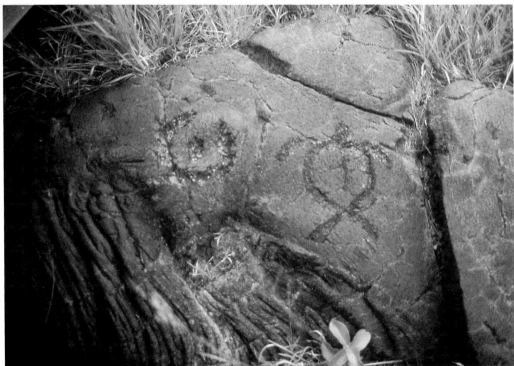

Petroglyphs of 'aumakua. *a.* Pueo *b.* Honu.

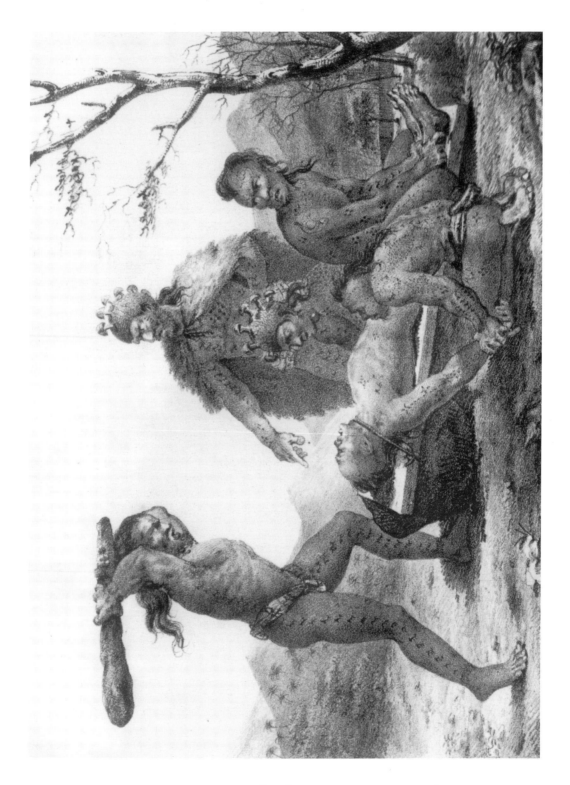

"The Execution" by Arago. Hawaii State Archives photo.

▲▲▲

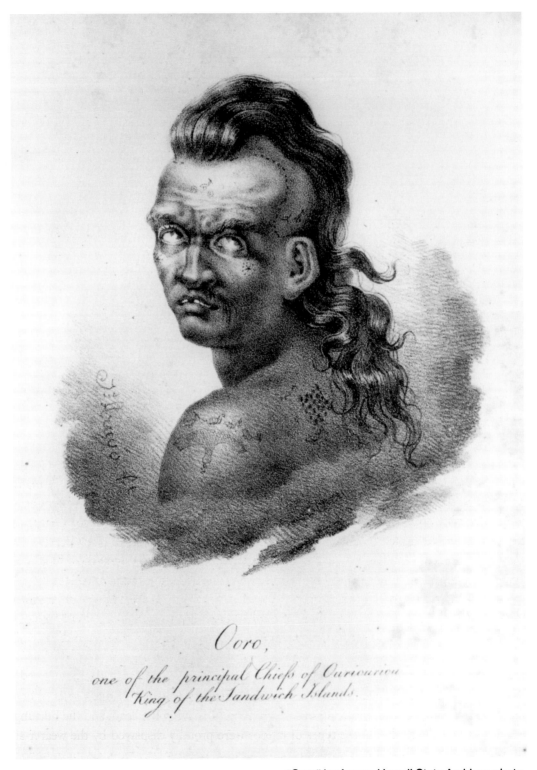

Ooro,
one of the principal Chiefs of Ourouriou
King of the Sandwich Islands.

"Ooro" by Arago. Hawaii State Archives photo.

CHAPTER 6

⯮ FLIGHTS OF FANCY,
PROOF OF GRIEF, MARKS OF SHAME

A tattoo, as much as jewelry, can be worn strictly for its decorative value. Plainly, many tattoo designs that appear in the sketches of old Hawai'i are there for the sheer decoration that they present. Not always were there religious or cultural reasons for wearing a tattoo and, as mentioned by Arago in 1819, he was constantly asked to draw designs on Hawaiian women. These were not traditional design patterns, for he remarked, "I assure you I drew my inspiration solely from caprice (whim) or from my studies at college."

With the arrival of the white men came many new and, to the Hawaiians, curious things. How the goat became a popular tattoo motif is still a mystery to me, but I suppose that a flight of fancy needs no real explanation. Even the rekindled interest and wearing of Hawaiian tattoos today can be explained mostly as fanciful decoration.

As well as decoration, grief was cause for the making and wearing of a tattoo. Not only did it commemorate the event, but it served as a permanent display of one's grief, much the same as the practice of knocking out the front teeth, shaving the head, and the burning of marks upon the flesh. These types of tattoos were proudly displayed by the wearer as signs of true affection and loyalty to the person whose memory they were meant to honor. Sometimes the acidic juices of certain plants were used to make a temporary tattoo of

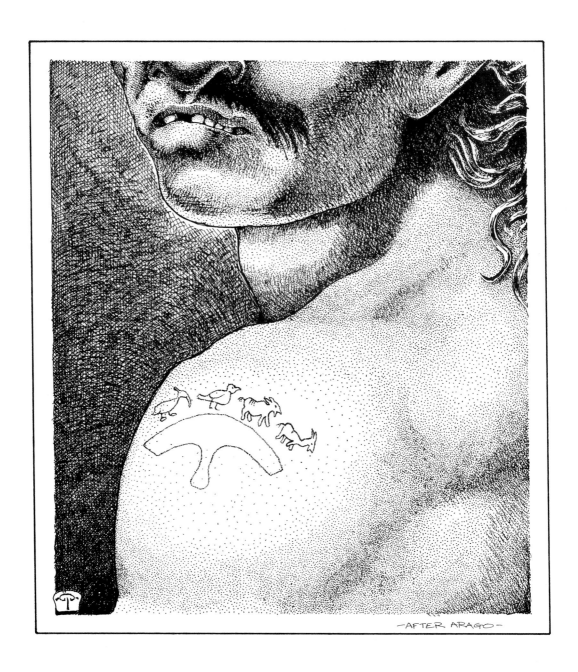

Artist's detail of "Ooro" displaying birds, goats and a fan, all popular post-contact motifs.

mourning. One such plant is the *mau'ula'ili*, a member of the iris family, whose acidic juice could produce a tattoo that would last for up to a year, but usually in a few months such tattoos would slough off, being replaced by healthy new skin.

One of the most painful areas of the body on which to place a tattoo is the tongue. In the 1820's, the missionary William Ellis wrote of seeing Queen Kamamalu receiving a tattoo on her tongue as an expression of grief for her recently deceased mother in law. When Ellis mentioned to her how painful the practice must be, she replied, "*He eha nui no, he nui roa ra ku'u aroha*" ("Great pain indeed, greater is my affection.").

Upon the death of Kamehameha the Great in 1819, many Hawaiians of the day had Kamehameha's name and the date of his death tattooed upon their body to show the respect they had for him. Even many years later tattoos were made to commemorate the death of a loved one, as in the 1899 account of Augustin Kramer, where he interviewed a man from Kaua'i who had tattoos of not only the *koa'e* (tropic bird), but the name of his wife, who recently had died, on his chest.

Probably the least desirable thing to be burdened with would be a tattoo that one had no choice in wearing. Such were the tattoos worn by defeated warriors and by the caste of people known as *kauwa*, or slaves.

In the case of defeated warriors, there are oral traditions that tell of the tattooing of the inner portion of the eyelid. Kamakau's account in the Hawaiian paper <u>Ke Au Okoa</u>, Sept. 29, 1870, tells of Kamalalawalu, the high chief of Maui, and his invasion of the island of Hawai'i during the reign of Keawe-a-Umi, the king of Hawai'i. Upon landing in Kohala, the men of Kamalalawalu captured Kanaloa-kua-ana, the grandson of Keawe. To show extreme contempt they beat him mercilessly and tattooed his body, then turned up his eyelids and tattooed them as well. The term *maka uhi* is used to describe the tattooing of the inner eyelids.

I suppose this type of tattoo, although shameful, would be easier to wear than that with which the slaves of old Hawai'i were marked. The slaves, or *kauwa* as they were called, were the property of the chiefs and were considered the untouchable caste of Hawaiian society. From birth the *kauwa* were destined to be slaves and tattoo marks were placed upon their foreheads and faces to identify them to all as a slave. This certainly prevented them from running off and starting life anew elsewhere, and the marks caused them to be the object of constant insults and derision. Many epithets were used when referring to the *kauwa*, among them were *kauwa lae puni* (slave with a bound forehead), *kauwa makawela* (red eyed slave), and *kauwa kikoni* (pricked slave). Some of the tattoos used to identify *kauwa* were described by Malo (Hawaiian Antiquities) as a round spot in the middle of the forehead, a curved line arched over the base of the nose, and a curved line on each side of the face next to the eyes, which made the eyes appear as if in brackets. Until this very day, arguments between persons of Hawaiian ancestry turn really ugly when one of the participants calls the other a *kauwa*. It is not a term taken lightly and is extremely hateful in its use.

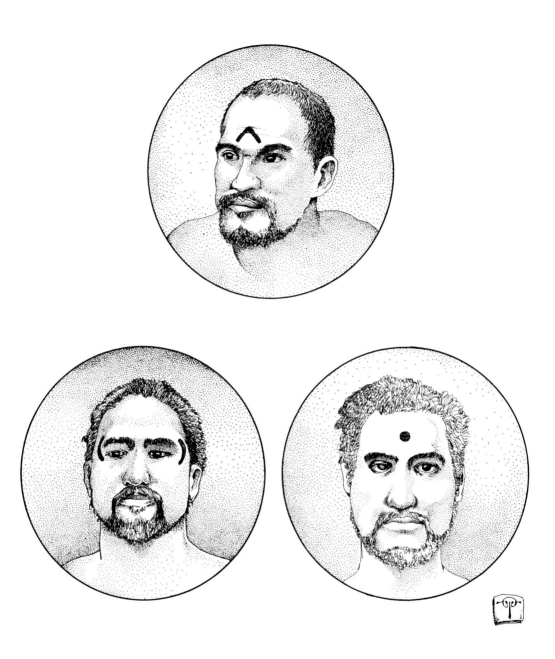

Artist's rendering of kauwa, or slaves, as described by Malo.

▲▲▲

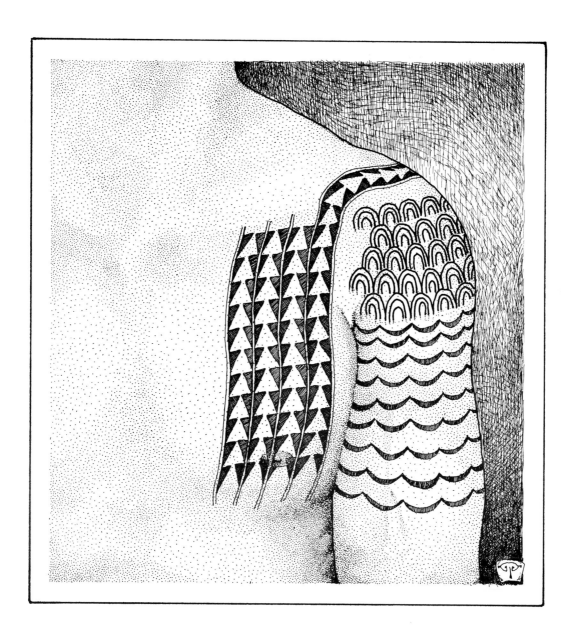

Artist's rendering of shoulder tattoos.

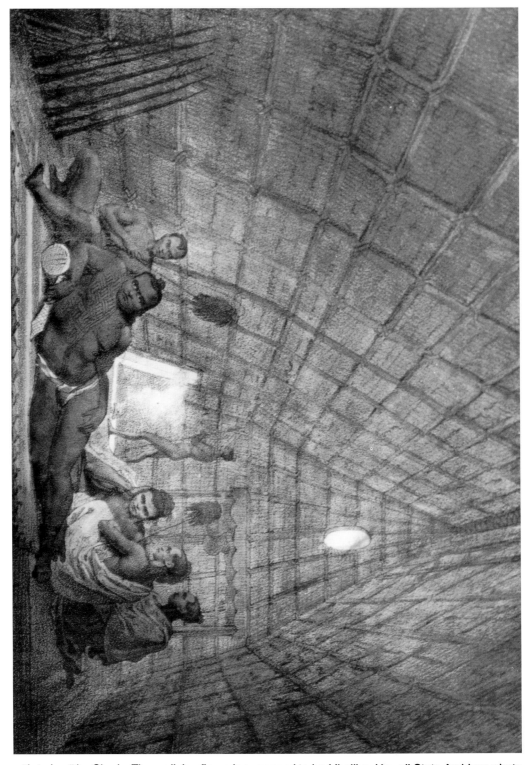

"Interieur" by Choris. The reclining figure is supposed to be Liholiho. Hawaii State Archives photo.

CHAPTER 7

⏩ EVOLUTION

The practice of making truly Hawaiian, pre-contact tattoos died out some time ago. Although no exact date can be given, it is safe to say that the practice had been absent in Hawai'i for at least 100 years prior to 1970. As noted in Chapter 1, the Hawaiian designs had become mixed with designs of foreign origin or influence, to include designs depicting foreign objects and the tattooing of names, as early as the late 1700's.

After the arrival of the American missionaries in the 1820's, the practice of tattooing was frowned upon as a pagan custom that was a reminder of the ancient religion and the idolatrous ways of pre-Christian Hawai'i. Tattooing was strongly discouraged and there is even biblical reference against it. In Leviticus 19:28 it says, "Ye shall not make any cuttings in your flesh for the dead, nor print any marks upon you..." Of course this only referred to the custom of tattooing as it pertained to a show of grief for the dead, nevertheless it is a biblical passage in opposition to the practice of tattooing, particularly to the type of tattooing done by Hawaiians to commemorate the death of a loved one.

As a general statement it can be said that there has been a revival of many Hawaiian cultural practices which started in the early 1970's. The ancient form of the hula, the making of tapa, and a renewed interest in the religion of ancient Hawai'i are among those things that have made a strong comeback. The Hawaiian tattoo has been one of the practices most neglected, particularly the tattoo of pre-contact motifs. These revivals of culture,

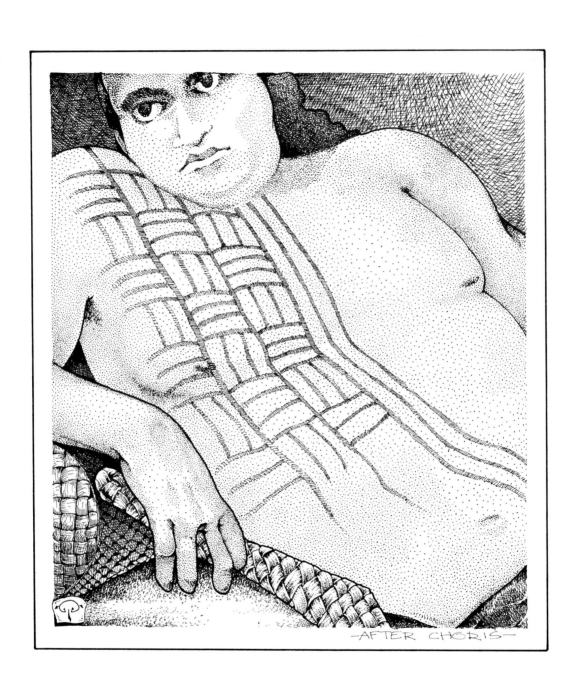

Artist's detail of "Interieur."

including tattooing, are also occurring in other areas of Polynesia that I have recently visited, though there is one universal stumbling block. Many of the old designs are still known to present day tattoo artists, but few, if any, of the old names and meanings of the designs are known. Sometimes this can lead to a misrepresentation or misidentification of certain motifs. Given the fact that there really are no Hawaiian tattoo experts around anymore, one might ask who is to say what is proper, what is genuine and what is appropriate in the identification of certain designs and design elements? My best advice would be to divide tattoo motifs into pre-contact and post-contact categories. Be they authentic or not, at least one would have a guideline from which to make choices and comparisons. For some of todays' Hawaiian type designs, there are quite modern meanings ascribed to them by their creators. One such case is a tattoo that was created for a particular hula *halau*, or school, in which geometric type figures are used in a very traditional way to represent fire, water, mountains, etc. This is a good example of modern day use of traditional stylings. Whether or not ancient designs actually portrayed such things is unknown, but their modern portrayal is unique and pleasing to the eye.

There is another side to the interest in Hawaiian type designs where the wearer or creator of the tattoo takes an everyday ancient Hawaiian object or theme and portrays it in tattoo with some very interesting, if not controversial, results. These are, of course, not replicas of ancient Hawaiian motifs, rather, they are Hawaiian subject motifs that are ancient. This serves to confuse many of the individuals receiving the designs because, in many instances, they are being told that what they wear as a tattoo represents something that it does not. Take, for instance, a design portraying a muscular Hawaiian warrior wearing a gourd helmet. Many youngsters of today call this an "*ikaika*" mask or helmet (*ikaika* meaning "strong"). This is a gross inaccuracy in that the helmet portrayed was actually used by ancient Hawaiian priests and was called "*makini*." This has become typical of the misuse and misidentification of what is called a Hawaiian design. This then brings up the question of who is right, the innovator or the purist? Innovation, in my opinion, is good, but being the purist that I am, I would say that the least present day tattooers should do is to advise their subjects that the design is not accurate. Then they should provide accurate information concerning the elements of the design chosen by the person desiring such a tattoo. In that way the wearer of the tattoo would be informed of what he or she is wearing and would not be misrepresenting this tattoo to others who would then pass on and perpetuate this misinformation. Many has been the time that I have asked individuals wearing one of these neo-Hawaiian tattoos about their meanings and I have been given answers that range from the simple and honest "I don't know,",to totally inaccurate and absurd fantasies or twistings of the actual facts. At other times I have had conversations with wearers of Hawaiian type designs and they have given me quite detailed information concerning the names of the designs and what they represent. One such person is Sam Ka'ai of Maui. He has several tattoo designs on his leg and uses the designs to commemorate events in his life. There is one design on his leg that is the *hala* pattern, which appears to go in alternate

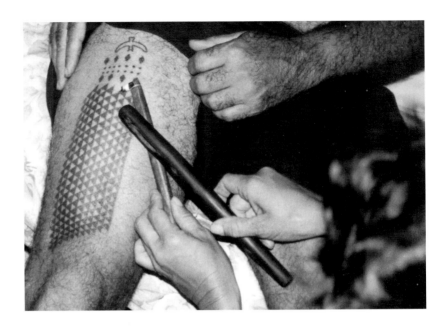

a. Darlene, the author's wife, tattooing the author with homemade needle.

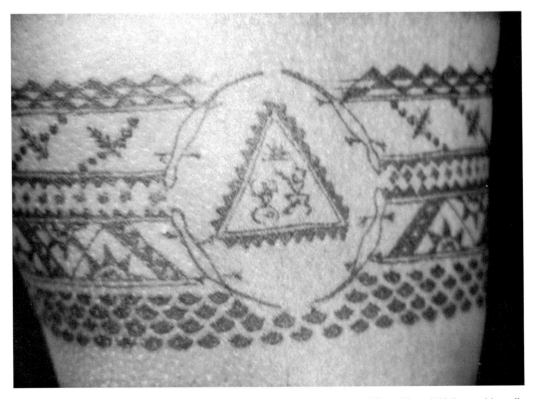

b. Armband design worn by Kimo Lim of Waimea, Hawaii.

directions, both up and down. Sam indicates that he made this tattoo to commemorate his trip between Tahiti and Hawai'i aboard the sailing canoe Hokule'a. It is a wonderful and innovative use of ancient Hawaiian design elements.

What, then, one might ask, is the purpose of wearing a hybrid design, or for that matter, one of the authentic pre-contact designs? Again, we have all the reasons previously stated. Fancy always takes precedence, but other reasons emerge with respect to today's renewed interest in the Hawaiian culture. Many times the wearer of a Hawaiian design tattoo is visually displaying a connection to their Hawaiian roots, if they happen to be of Hawaiian ancestry, or to be socially recognized in a Hawaiian, or "local" context if they are non-Hawaiians. For the purist it is an attempt to recreate and perpetuate a part of the Hawaiian culture so long neglected. Those who fall into this category often seek out the meanings of the designs and most choose designs that have ties with their genealogy, 'aumakua, or that commemorate events of importance or spiritual significance.

The interest in obtaining an authentic looking Hawaiian tattoo has been so strong of recent years that some Hawaiians have travelled to Tahiti or Samoa in order to obtain authentic looking designs. The downside of that is that they have not obtained a "Hawaiian" tattoo, but a Polynesian tattoo instead. Many Hawaiian tattoo designs are now rendered in the form of an arm band, which was not a normal feature of Hawaiian tattoo design. It is a feature borrowed from Samoan tattooing. Bands, per se, were normally placed around the ankle and wrist and the majority of this type of tattoo was worn by women. This does not mean that a Hawaiian design cannot be worn in the form of a band. It is certainly the most popular type of tattoo now being made and worn in Hawai'i. I have even seen persons of mixed Polynesian heritage combining the elements of each culture into their unique tattoos, such as a Samoan band with certain Hawaiian elements mixed in.

If you are considering a Hawaiian tattoo design for yourself, some careful thought should be made. First and foremost is what you take a liking to. This is essentially following the desire of your heart. Another consideration is whether or not you want to portray something with ties to your genealogy, your 'aumakua or maybe even your occupation. It is not known whether or not Hawaiians of old represented their occupations in tattoo elements, but imagine a fisherman wearing the design of a fish net, which is called 'upena in Hawaiian. What an interesting display that would be. Some thought should also be given to designs that might be in opposition to one's family 'aumakua. In the case of choosing an 'aumakua design, thorough research should be done to correctly identify your particular 'aumakua. As mentioned in the chapter on 'aumakua, even the names of the particular 'aumakua were known to the people of old. If the name is not known, then they can be portrayed generically (shark, owl, etc.).

It should be pointed out that there is always an underlying element of "macho" that is present in all tattoos, and this was true of ancient tattooing as well. Only a person who has felt the pain of the tattoo needle can truly appreciate what another has gone through to obtain a tattoo. It certainly is a test of one's ability to block out or absorb pain of varying

degrees, depending on the body part to be tattooed and the amount of skin covered by the tattoo. In Samoa those persons that undergo the ritual tattooing that covers the area from knee to abdomen are treated as wounded warriors and are acknowledged for their bravery in completing such a painful test. Until this very day people have been known to die from toxic shock while undergoing this type of tattooing!

For whatever reason one might wear a Hawaiian or neo-Hawaiian tattoo, there is no denying that the practice of tattooing in Hawai'i has gained a popularity that has been absent for many generations. In the true sense of the word, there has been no real "evolution" of Hawaiian designs, in that the practice died out many years ago. For a true evolution to have taken place there must have been a continued progression of tattooing in Hawai'i of those designs identified as Hawaiian, whether of pre-contact or post-contact motif, and this has not been the case. There is, however, by definition, a renaissance or re-birth of the Hawaiian tattoo, as authentic or contrived as they might be.

I might also add that a worldwide interest in "tribal" type tattoos has become the latest rage. I have seen people from Europe sporting tribal type tattoo bands, and upon inquiring what they represented I found, much to my surprise, that they represented Viking motifs! I suppose ancient Hawaiian designs could be categorized as "tribal type" designs.

In this book I have attempted to provide the most accurate descriptions of Hawaiian designs possible and, where possible, to show that their near relatives, designs from tapa, mats, gourds, etc., can give us clues to the names used for some of the ancient motifs. Certain designs and motifs will always have their underlying meanings, or *kaona*, kept secret, and so it should be. Even in the days when tattooing was widely practiced in old Hawai'i, the *kaona* of many designs was known to only a select group of individuals or kept within the family. I have been privileged to have information shared with me from certain families that I cannot share with anyone in the writing of this book. This information, nevertheless, will be passed on within the families in which they are kept. It is heartwarming to see that the Hawaiian tattoo is becoming part of the Hawaiian family again. I have seen fathers tattooing sons and once again the Hawaiian tattoo takes on a pride that has been missing for many generations.

It will be interesting to see how far this renaissance in Hawaiian tattoos will go. It will continue to be an interest sparked with much concern and controversy between the purists and the innovators, but an interest nonetheless. How far will neo-Hawaiian designs depart from, or come back towards truly Hawaiian designs? Ancient Hawaiian tattoo motifs are a very small part of the culture from which they have come, but to lose any part of a culture is to never fully understand or appreciate that culture. It does not mean that we must shed the ways of the modern world and live in the past. What it really means is that we must take note of, and attempt to understand as much of, the aspects of our culture that make us unique in the world, and yet re-affirms the bond we have with our Polynesian cousins throughout the Pacific. We need this knowledge to understand where we came from and where we, as a people and culture, are going. A person without a beginning is like a story

with no beginning, it is not clear and has no foundation. For this reason we must perpetuate this and other aspects of the Hawaiian culture, so future generations of Hawaiians will be able to do the same.

PAU

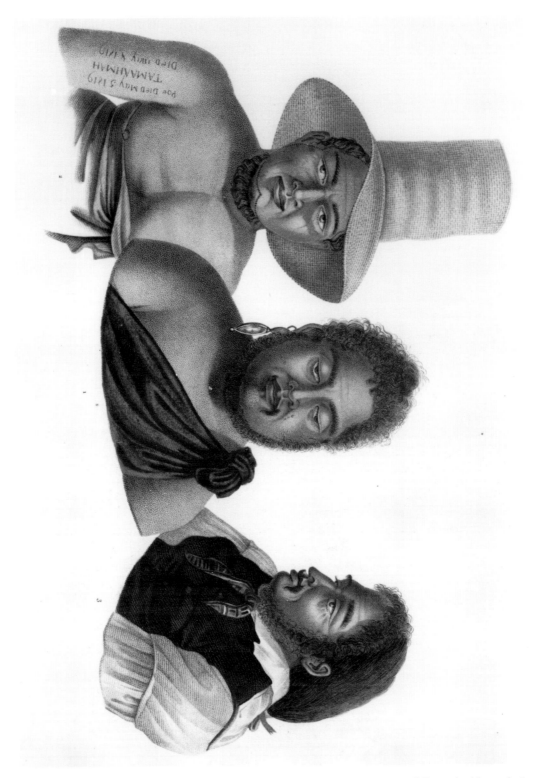

"Iles sandwich" by Pellion. Hawaii State Archives photo

BIBLIOGRAPHY

AUWAE, Henry. Personal communication, 8/1/96.

DEGENER, Otto 1930. Plants of Hawai'i National Parks Illustrative of Plants and customs of the South Seas. 1975 reprint by Braun-Brumfield, Inc.

EMORY, Kenneth P. 1946. "Hawaiian Tattooing", Bishop Museum, Occasional Papers.

HANDY,Willowdean Chatterson 1922. Tattooing in the Marquesas. Bernice P. Bishop Museum Bulletin 1. 1971 reprint by Kraus Reprint Co.

KAMAKAU, Samuel M. 1964. Ka Po'e Kahiko: The People of Old. Bishop Museum Special Publication 51.

KIRCH, Patrick V. 1985. Feathered Gods and Fishhooks. University of Hawaii Press.

KRAMER, Augustin. 1903. Die Samoa-Inseln: Entwurf Einer Monographie Mit Besonderer Beruchsichtigung Deutsch-Samoas.

KWIATKOWSKI, P.F. 1991. Na Ki'i Pohaku; A Hawaiian Petroglyph Primer. Kupa'a.

MALO, David. 1951. Hawaiian Antiquities, translated by N.B. Emerson in 1898, Bishop Museum Press.

McLAUGHLIN, John. 1973. Hawaiian Tattoo Motifs, unpublished manuscript in the archives of the Bishop Museum.

PUKUI, Mary K. & ELBERT, Samuel H. 1971. Hawaiian Dictionary. University Press of Hawaii.

TAYLOR, Alan. 1981. Polynesian Tattooing, Pamphlets Polynesia.

TAYLOR, Richard. 1870. Te Ika A Maui; or New Zealand and Its Inhabitants.

◥◥ ILLUSTRATIONS

PAGE

"Strangulation" by Arago. Hawaii State Archives photo. ... iv

"Dance by Hawaiian Men" by Choris. ... vi

Artist's detail of tattooed dancer. .. x

"Death by Captain Cook" by Webber. ... xi

Artist's detail from "Death of Captain Cook." ... 2

a. Hawaiian tattoo designs on female mummy. Bishop Museum photo. 7

b. Tattoo on Hawaiian man described by Kramer as Koa'e birds. Bishop Museum photo. 7

"Hawaiian Officer" by Arago. Hawaii State Archives photo. ... 8

Tattoo needles from the collection of G. Hedemann. Photo by Michi Hanano. 10

a. Author's homemade tattoo needles. Author's Photo .. 11

b. Ancient Hawaiian tattooing instruments. Bishop Museum photo. 11

Artist's rendering of female hand tattoo motifs after a drawing in K.P. Emory's Hawaiian Tattooing, BPBM
 Occasional Papers, 1946. .. 16

a. Finger design from a Hawaiian female (mummified remains). ... 17

b. Palm tattoo from a Hawaiian female (mummified remains). .. 17

"Hawaiian Warrior" by Arago. Hawaii State Archives photo. ... 18

Artist's detail of checkerboard or "papa konane" pattern. ... 20

Portion of Niihau makaloa mat showing various designs. Bishop Museum photo. 22

a. Hawaiian kapa beaters with 'upena, ko'eau and niho mano motifs.
 Bishop Museum photo. ... 23

b. Bamboo tapa stamps. Bishop Museum photo. .. 23

Kalaipahoa, or poison god image with lizard tattoo motifs on the face. Bishop Museum photo. 25

"Hawaiian Tatooed Man" by Webber. Bishop Museum photo. .. 26

Niho Mano variation .. 27

Design designated as "Ala Nui O Kamehameha" by a leper
 on Molokai as told to Augustin Kramer in 1899 .. 28

Bird motif with rows of connected triangles after a tattoo from the arm of a mummified female. 28

Niho Mano, Pyramid Style ... 29

Niho Mano, Linear / No Border ... 29

Niho Mano, Pattern Single Strand ... 29

Liholiho Pattern ... 30

Alternating Ladder Design ... 30

after darwing of dancer by Choris .. 30

Bar Design .. 30

after drawing of dancer by Choris .. 30

Various designs, combining niho mano elements. ... 31

"Maui Woman Dancing" by Arago. Hawaii State Archives photo. .. 32

"Young Woman of Hawaii" by Arago. Hawaii State Archives photo. ... 33

Artist's detail of lizards on the face of Kalaipahoa image in the Bishop Museum. 34

"Baptism Aboard the Uranie" by Arago. Hawaii State Archives photo. .. 36

Artist's detail of ankle and calf tattoos. .. 37

Petroglyphs of 'aumakua. a. Pueo b. Honu. ... 40

"The Execution" by Arago. Hawaii State Archives photo. ... 41

"Ooro" by Arago. Hawaii State Archives photo. ... 42

Artist's detail of "Ooro" displaying birds, goats and a fan, all popular post-contact motifs. 44

Artist's rendering of kauwa, or slaves, as described by Malo. ... 46

Artist's rendering of shoulder tattoos. ... 47

"Interieur" by Choris. The reclining figure is supposed to be Liholiho. Hawaii State Archives photo. 48

Artist's detail of "Interieur." ... 50

a. Darlene, the author's wife, tattooing the author with homemade needle. 52

b. Armband design worn by Kimo Lim of Waimea, Hawaii. ... 52

"Isles Sandwich" by Pellion. Hawaii State Archives photo. ... 56